Geneses

Rob Myers

robmyers.org

gitlab.com/robmyers/geneses

ISBN 978-1-329-80835-5

Copyright ©2016

"Geneses" by Rob Myers is licensed under a
Creative Commons Attribution-ShareAlike 4.0 International
License.

With thanks to Seryna.

A poem consisting of
the genesis block hashes from
the hundred cryptocurrencies with
the highest market capitalization
on January the Second, 2016
encoded as BIP-0039 mnemonics.

Geneses

1. abandon abandon abandon ability output crowd ice area thumb clown sibling charge youth range ribbon stairs plug argue provide toddler gaze edit meadow update

2. gaze abstract quit cargo daughter scrub father drastic cry civil pill patient sad decade shrug sample illegal jewel pink chef patrol enroll excess enroll

3. bargain depth juice divide staff coast twin duck celery silent sweet cover oil slide fashion grief use camp main reject tree across zebra farm

4. balance tent cycle organ element point crane hurdle broken breeze decrease hint spring strategy sorry honey slim swift mixed sense expose miss armor fame

5. abandon ability wagon demand census help december riot purity scale this asthma pill useful truck milk seed interest chunk video slot camera artist horn

6. box monitor wall organ hotel gallery used alcohol play record leisure aerobic present twin salad friend sister lift proud coral lizard boy fog cup

7. abandon abandon abandon abandon salad hybrid naive tube immune spoon finish tuition alter distance arm need dolphin cool true solve garment net offer accuse

8. melt treat top medal wet someone wink pink middle lab thank owner foot pride mad

9. degree bench viable little brass dream what brand ecology average poverty model edit account spot music cram either around charge comfort whip pudding boost

10. cement museum bag agent camera frequent

11. gospel payment enlist charge chimney blouse filter chat dirt brisk cost fatal detect cheap autumn soccer absurd affair erode shift damp garbage bomb kick

12. silk guard fun isolate valve milk curious inform bless crunch alpha picture abstract sound produce spike occur trial whale acquire blanket merry shaft cricket

13. abandon abandon abandon absorb clock normal judge output echo tattoo bid wonder amazing apple history reject curious crane author warrior congress female build badge

14. cheese pitch boring moon wire chase phrase student aware excite color wage auto undo mask shiver work stage pudding pull total mystery turn pave

15. abandon ability hammer month defense voice leisure visa model deer venture sort champion phrase galaxy ribbon state mango promote divert place arrive filter deal

16. abandon abandon vessel forget foam eyebrow chase pattern flip genre clay indicate faith solve icon dog used mercy kid moral state frost friend walnut

17. abandon abandon ability kangaroo snap coconut dolphin start match marine catalog other surface rival clutch april dad offer jewel pluck crush injury cost remember

18. media adapt language strategy float gossip expose cash peace oven chef traffic cram volcano hurry bicycle napkin idea leaf enter away material forum rubber

19. abandon about address winter tumble galaxy this people tilt reunion wrestle peanut light canyon endorse snap shove eye release fee phone plastic fiction actual

20. abandon about august sniff diesel balcony minute duty phone rubber depth fashion sudden erosion one stove prefer stable tortoise cable ridge crunch holiday rose

21. abandon ability hill useful gas spare nothing sail invite slide stock crisp drastic lyrics thank agree citizen pave sort shoot crew super include submit

22. zebra wedding able color border view chaos shove echo announce lazy surface save airport tank stove exist runway trouble foster staff shock conduct scorpion

23. abandon able unit hill soon village jeans soup body gadget dune prevent churn quit sort logic shiver key artist much wedding fish bachelor attack

24. drum guilt miss robust remember alley slogan dad sample pottery eyebrow inherit absent clutch digital leopard coil process rapid popular life spell convince olympic

25. abandon abandon abandon abandon abandon absorb raccoon police force vibrant ceiling sibling basket candy cousin whale define actress meadow bone smooth banner turkey right

26. abandon abandon pluck cake salon sick educate project bind fall skate scrap add dress mango across pass order style total solution record extend enrich

27. abandon ability banner social document limb stairs suffer pyramid scan gaze price wasp bulb visit cricket raccoon congress require lab gadget cruise insect stomach

28. abandon abandon abandon abandon abandon clock grid firm invite road apple remain save high furnace eye trouble blue comfort bike duck twenty gorilla meat

29. abandon abandon abandon abandon abandon abandon aspect size pride spike enroll half inch drum song about chef hub weapon tuna immense tiny announce poverty

30. abandon able light all hole swear sausage coffee grid hat ten athlete obvious miracle input firm pitch town mass space arctic nest soldier mango

31. devote undo armor flower tomato cook indoor dune will artist drum mystery advice penalty illegal shrug carry avocado swim spirit divert close pony magnet

32. abandon abandon abandon seven flight voyage abstract just verb virus fire room select laptop nominee ribbon install panel phone medal artist token afford scorpion

33. exercise curve hint swallow meat party fan wine father brief gather innocent alien grocery note shift task mountain verb faint tunnel switch risk onion

34. abandon able elevator town fantasy acid cannon try wash apology debris reject small clutch power sight stick sound fitness rotate myth tattoo front nephew

35. normal trim update oppose inside mean acid begin voice fit solid version insane bargain borrow earth pupil weird patch window old appear lottery scorpion

36. abandon abandon vessel forget foam eyebrow chase pattern flip genre clay indicate faith solve icon dog used mercy kid moral state frost friend walnut

37. abandon abandon burden chaos cycle empty alert hole behind ostrich mansion attract idea tide explain boring easy mouse produce myth business usual north equip

38. abandon able kit gown pottery purse misery hello dog yellow secret renew vocal danger assist punch stuff brother lucky corn flee smart capital clever

39. abandon abandon adjust below gate execute rail say night faint black quick true rotate pond panda law door fantasy express object someone gasp firm

40. innocent satisfy man million twenty sort impulse tube knock dry sea cabin accident hidden version swim pudding spring crash breeze shoulder aunt banner scrub

41. abandon about raw educate vacant want change field dish fatigue tackle vast sheriff erode price once decrease music draw decide pitch main memory half

42. abandon abandon depth puzzle rival bachelor desert junior noodle index machine grab spare security cook also trust slice elegant thank pill recipe have avocado

43. abandon about announce warm demand resemble harbor glide play broom culture seek great party small fantasy evolve fog boil clarify shield suffer rebel rigid

44. music glass siren tag path wonder hint whisper surge horse harsh picture churn truly impact whale rally swear title six butter question senior swamp

45. abandon about inner glow dutch notice key stone legal desert know remove service amount garment negative world magic boat scatter gauge frame stay space

46. abandon abandon fruit recall lyrics purchase shock broom gospel inquiry uniform expect round detect long dynamic public oblige stool silent scout favorite under radar

47. escape goat trust salute trash wolf plastic giant home deer hire domain true swear meat cake axis faint sibling tail grit scare peanut floor

48. impulse mirror bomb pond ginger glance grain betray soda enrich whisper critic bring zone swift say ill entry dust motor foil license advice vote

49. camera test index captain fresh home brand book three quick horse female leopard public flight banner firm slush crucial mushroom they cook key scale

50. gather trick acid brick sing doctor capital exchange stereo wrap suit alert win penalty hip spawn scout cram arrow spend clump tower team width

51. abandon abandon bind measure artwork allow wing aim shadow tobacco inflict august horse orbit swap swing recipe join hip coast strategy east monitor april

52. trick cricket canyon cloud quick work census chaos team moment enjoy unaware wrap pledge volume cluster image old inside cabin zero focus glimpse milk

53. abandon about parrot noise model grape wrestle song steel zebra jelly rough corn black book virtual cream trigger margin assist happy purse nurse jaguar

54. trap broken fade write table ugly stick garden nature panel fog give moral same eyebrow aerobic arm indoor dog reject evolve thrive auction seven

55. cannon message fat trend credit asthma belt bullet slide stumble shiver simple depart lobster sketch jealous sugar gloom census cat convince mechanic recipe sad

56. rain helmet path enter common bitter invite tomato note three crawl select cherry fire primary object clerk minor general file wish student wrap release

57. reveal either curve refuse sense alpha cute rhythm leave club turkey victory silly grass toy shuffle enroll mass dirt prefer resemble genius kite lonely

58. abandon abandon ripple speak position sketch lonely hedgehog oak potato please visit still find clerk swap robust mass quarter cargo result muscle armor letter

59. eternal relief earth truck staff flight novel explain escape warfare rescue now abandon outer goddess oil patrol girl ensure during aware eager seek melody

60. abandon ability poverty refuse elevator ranch cement episode tornado tone delay undo sphere bottom bullet diary rail violin so

65. abandon able supreme muscle world taxi moon verify file honey ladder perfect sunset trend cook color organ empty invite measure field upgrade frost ripple

66. abandon abandon ability crumble misery forum cover boring mix stool dust suffer enemy fix female play mix weird churn inner torch demise page phrase

67. chef release accident wrestle van price pottery trash future ecology flower crater hover funny fitness vault admit prepare immense drama casino imitate twice matrix

68. vast ignore carpet blossom mixed enter multiply copy wet measure survey piece agent way relief fame fatal beauty huge opinion slam control six remember

69. abandon abandon depth puzzle rival bachelor desert junior noodle index machine grab spare security cook also trust slice elegant thank pill recipe have avocado

70. brand animal room machine divert bundle slush match melt shove fiction churn list vivid firm apology frog giant argue first subway laundry boring obtain

71. debris bar mix hat worry capital dream remain rotate nut staff comfort print strategy flat broom risk helmet broom dizzy scrap know cash camera

72. abandon ability blanket valley pen kit faith payment laptop matrix lawsuit large please saddle pulp people aisle history property case acid close deer theme

73. avocado bread park trend replace position

74. morning behind among license often tomorrow ritual error middle series arm special bind peace airport surface life pole hungry palace bless weird join timber

75. east naive guess lake tornado rice change sight ill panel few chuckle lift sound picnic risk enemy corn pelican conduct half shoulder post skull

76. clever identify across income nest liquid safe enter embrace coach resist price hen start mass stick actual amateur turn volume elbow float tuition sibling

77. abandon ability razor hungry pencil vapor heart cage flip best much random sting tape bulb boss into bread expose describe observe junk zone oak

78. abandon abandon off reject candy pride flag steel royal market slogan gain divide main dawn world blame twelve cluster pluck find answer damage cave

79. abandon abandon abandon future obscure abandon wasp emerge pause cricket glance agent build wheel misery owner mouse system maximum close shaft dirt bottom sniff

80. abandon abandon save kangaroo weird wait whale return battle debate nice strong cradle pelican area wheel choice scene fetch asset safe cram worth iron

81. collect barely duty crater apple transfer reward brief battle glimpse arrow spice foam allow grid battle cattle metal brand exclude method south lounge fiber

82. abandon abandon area business grab share right hungry demand possible axis table decorate dawn limb unfold combine steak venture govern print extra grain obvious

83. abandon ability legend antenna eye club ignore season custom token decade lawsuit correct project athlete loan piece bargain tent able gym hood stadium middle

84. abandon abandon rule client retreat kitten grab paddle jealous audit surprise sick pink priority gossip weekend walk indicate liquid tomato cup helmet sting witness

85. judge inquiry swim way angry era clerk gaze close office hello neck prison help pair chunk toilet ensure pudding hotel real drive people patrol

86. sign good duck pipe inject sheriff penalty endorse kitten one cup word unhappy dinner credit guess distance away want siren deliver wrist grow magnet

87. abandon about grace giggle supply beyond fringe north van bounce infant buddy logic cruel mail defense lift naive action wolf project crop advice animal

88. abandon abandon badge tail unlock upgrade collect network learn phrase moment betray print fix nice cinnamon lazy jeans mango social resemble dolphin ridge wet

89. abandon about parrot noise model grape wrestle song steel zebra jelly rough corn black book virtual cream trigger margin assist happy purse nurse jaguar

90. abandon able ski very cart curious garden clown tiny theory bike cupboard coil regular solution craft dream member sister sun swarm approve song flag

91. game outdoor throw crop away labor next wisdom typical must just poverty define swarm marble ship drink inspire above water original turn miss snap

92. abandon able dinner toddler spring mirror license trumpet note october life call proof route clean jeans allow brand purity skate stamp shoot later damp

93. abandon abandon able prepare task evoke wrist sentence small example found relief ice fresh half hen spoil pumpkin fish control ghost reject basic matter

94. habit oppose wall more script liar pole canvas exercise wasp wash door visit body jeans witness soup spawn best breeze arrest rocket omit catch

95. recycle access display index two fee earth across doctor harvest exit uncover table crucial shine sunset drink tube tackle rifle lamp gaze drill amount

96. abandon ability add salt present will crumble snake pizza jealous style bring bitter derive badge minimum wheat table catalog flag invest stomach blouse demise

97. frame engine upset guess doctor bundle slush letter industry adult pizza casual alarm mosquito flight marble garment simple party copper student rescue sugar vast

98. begin agree long audit sand nasty calm dutch enroll physical thought age alien room friend prefer outdoor toss ski sustain decade evil awesome curtain

99. abandon ability snack escape aunt faint future kidney enhance mouse coin hotel shoulder mistake rail property dice harsh thrive pottery engine game fitness promote

100. abandon abandon abandon seven flight voyage abstract just verb virus fire room select

Coins by Market Cap as of 2016-01-02

1	Bitcoin
2	Ripple
3	Litecoin
4	Ethereum
5	Dash
6	Dogecoin
7	Peercoin
8	Bitshares
9	Stellar
10	Nxt
11	factom
12	Monero
13	Namecoin
14	Bytecoin
15	GridCoin
16	NuShares
17	EmerCoin
18	RubyCoin
19	BlackCoin
20	Clams
21	YbCoin
22	MonaCoin
23	Startcoin
24	NEM

25	Counterparty
26	Global Currency Reserve
27	BitcoinDark
28	Mastercoin
29	Bitcrystals
30	Novacoin
31	Rimbit
32	Ixcoin
33	CasinoCoin
34	NeuCoin
35	PrimeCoin
36	NuBits
37	AmberCoin
38	VeriCoin
39	PayCoin
40	DigiByte
41	ShadowCash
42	IOCoin
43	Quark
44	GameCredits
45	Mintcoin
46	VPNCoin
47	NautilusCoin
48	WorldCoin
49	DNotes

50	Megacoin
51	Vanillacoin
52	SolarCoin
53	BoostCoin
54	DigitalNote
55	EarthCoin
56	Infinitecoin
57	ReddCoin
58	Diamond
59	Vertcoin
60	FuelCoin
61	Gulden
62	Feathercoin
63	ARCHcoin
64	FedoraCoin
65	Applecoin
66	Unobtanium
67	Crypti
68	FairCoin
69	I/O Coin
70	Electronic Gulden
71	NetCoin
72	FlyCoin
73	BilShares
74	Anoncoin

75	Digitalcoin
76	Auroracoin
77	Zetacoin
78	Crypto Bullion
79	CureCoin
80	UnionCoin
81	CloakCoin
82	MaxCoin
83	HyperStake
84	TEKcoin
85	Riecoin
86	SysCoin
87	BitBay
88	AsiaCoin
89	Horizon
90	TagCoin
91	Virtacoin
92	CannabisCoin
93	ZcCoin
94	Orbitcoin
95	SpreadCoin
96	Blocknet
97	PotCoin
98	Aeon
99	DogeCoinDark
100	Devcoin

www.ingramcontent.com/pod-product-compliance
Lightning Source LLC
Chambersburg PA
CBHW072310170526
45158CB00003BA/1268